Copyright © 2021 by
Zenith Literary Magazine
All rights reserved. No part of this book may be reproduced or used in any manner without written permission of the copy-
right owner except for the use of quotations in a book review. For more information, email:
zenithlitmag@gmail.com
First edition 2021
Book/cover design by Zenith Literary Magazine
ISBN 978-1-329-08696-8
zenithuiowa.wixsite.com/zenith

Letter From the Editors:

Dear Reader,

Approximately four months ago, a class of 14 strangers put their trust in us to guide them toward a collective vision and create a literary magazine. As the chosen senior editors, our first responsibility was to each other. Through hours worth of texts, calls, emails, and meetings, we grew to love and appreciate each other endlessly and effortlessly as a Libra and Aries power duo. At this point, our bond is that of family, and it has translated to our whole team. We learned to support, appreciate, and respect each other through time, work, and Zoom calls. Our passions brought us together, transforming us into the Zenith family. We were all drawn to our concept's intangible, undeniable allure—in our eyes—this issue of Zenith is the closure we needed after the year our world has had. We asked creators to share the most vulnerable parts of themselves and the submissions we received reflected the raw emotions we observed in ourselves.

Thank you to our resilient team members Kaitlin, Emily, Charlotte, Hayden, Madi, Maya, Eden, Elyse, Sarah, Evalyn, Della, Courtney, and Jillian. Each one of you deserves the best this world has to offer, and we are extremely grateful for your hard work and dedication. To our mentor Jess, we thank you for your patience. Your calm aura helped shape us into well rounded leaders. To our inspiring creators, without your voices we would have nothing to offer, and we are eternally grateful to you for making Zenith a reality. To our readers, we see your grief, your joy, and your moments of power. Please allow this issue to be your safe space and catharsis.

To Cata,

There is no way for me to properly express my gratitude. You challenge and inspire me more than anyone I have ever met. I admire your passion, strength, and determination. I am indebted to whatever power brought us together. Thank you for giving me and the rest of the team every reason to keep pushing.

With all my love,
Mikey

To Mikey,

I thank you for your endless support, appreciation and friendship. We have held each other steady throughout this hectic process, and I am so very grateful to be able to count on you. Words could not do justice to how much you have brought to this magazine. Zenith and I are lucky to have you. Thank you from the bottom of my heart.

<div style="text-align: right;">Con el cariño de siempre,
Cata</div>

 One of Zenith's aims is to highlight that power can and does stem from vulnerability, so we encourage you to view the following pieces through this lens. This issue's content is possibly triggering to some readers, please keep yourself safe and look out for content warnings.

 Our first issue came together in long nights, deep breaths, and what truly felt like the end of the world. Now, we present to you a magazine that encompasses the 2020 experience from the eyes of our contributors. This issue was born out of the rawest and most powerful moments from both our contributors and team, and we hope that is expressed on every page. It is our wish that you find these pieces to be echoes of your own experience, and know that whatever it is you felt this year, you were never alone. Please allow that to bring you solace.

<div style="text-align: right;">Our very best (and see you soon),
M & C
Mikey Waller | Senior Editor.
Catalina Irigoyen | Senior Editor.</div>

Table of Contents:

2	Letter from the Editors
3	Table of Contents
4-6	Everyone is Bad in theCoronacene
7	fortune cookie :(
8	Dumpster Fire
9	self destruction is easier than self care
10	Comandatore
11	Circles of Silver
12	How We Shoud Be Born
13-14	Little Woman
15	*Untitled* by Eva Long
16-19	Private Show
20	Grief in Eight Acts
21	Born this Way
21	Individuation
22-23	merry star dust
23	Everyday Saint
24-25	To Rest on Concrete
25	haiku #25/05
26-28	Blue and Pink Make Purple
27	ajna
29	windows
30-31	rebegin
32-34	ON A THURSDAY, MY THERAPIST ASKS
35	*Untitled* by Eva Long

36-37	Dimmed Lights
38-39	dreams
39	Painted Doors, Shuttered Windows
40	july
41	One With Nature
42-43	Vaseline
44	hold
45	The Birds
46-47	Lemon Drop Martini
48	Visions of a Blind Fountain
49	Sun Tides
50	*the drive before i left*
51	From The Inside Looking Out
52	A Better Art
53	*LAST ONE OUT OF TILLER, TURN OUT THE LIGHT*
54-61	creator bios
62-69	meet the team!
70-73	your zenith horoscope
74-75	Thanks for Reading!

Content Warning: Suicidal Thoughts

Everyone is Bad in the Coronacene:

I wake up at 8:55 a.m. everyday but go back to sleep until 9:21. I know with a bizarre certainty that I will wake up at 8:55 every day. Time moves differently, has an elasticity that means that when I wake up on day 125 (?) of lockdown, it feels like the beginning to a journal entry I wrote three months ago. It feels that way because it is. I'm allowed to lie in bed for seven minutes, contemplating the nothingness before I must get up and face last night's dishes. Every morning.

Every morning there is Vitathion, a sachet of immune-boosting vitamins. I can't decide if I think it's working yet or not, but it's not not working because I haven't got the virus yet, so I drink it. I mix it in with a glass of water and stare at the swirling pink concoction. I wonder if that is the most beautiful thing I will see today. I have this same exact thought everyday at 9:45.

I wonder if I should clean my windows, and then wonder how I would go about doing that. I wonder if it makes a difference because no one will see them anyways, and I wonder if only caring about having dirty windows when others will see them makes me a disgusting person. I don't think I care. I switch on my phone, and the day begins.

It is all-consuming, this new version of being online in the pandemic, if it's possible to get more all-consuming than it was before. Confined to our dirty homes, we have taken to the virtual space, shouting and performing, desperate for some kind of perverse recognition. I am confronted by an Instagram graphic that screams, "MUSLIMS ARE BEING SKINNED ALIVE," followed by a MasterClass advert of Thomas Keller skinning salmon. It is an onslaught, this new social media, and the algorithm works tirelessly to create a carnival of horrors, through which I swipe listlessly. I wonder, for a few agonizing days, if there is violence in the swipe, in the turning away, the refusal to bear witness. But there is only so much we can bear, I reassure myself. I feel better.

"Confined to our dirty homes, we have taken to the virtual space, shouting and performing, desperate for some kind of perverse recognition."

I consume with a pathological determination that borders on unhinged. I read *White Fragility* and hate it, but not because of my own white fragility, I don't think. I hope. I watch movies every day and it is only after six months that I realise this is what escapism looks like. But it doesn't matter. I started the lockdown with *Mona Lisa Smile* and have worked my way through 126 films to *The Young Girls of Rochefort*. I proudly tell my sister I am watching French films. She tells me to stop being a snob.

I read about how biracial rapper Doja Cat is exposed for having shown her feet to an online community of

Reflections from a Locked Down Cape Town

white supremacists, and people on Twitter are saying that if she had a black mother and a white father instead of a white mother and a black father, this would never have happened. I do not know why or even what that means only that it seems important. A lot seems important. A friend keeps telling me, "I don't think we will realise how important this all is until it has been over for a very long time. We're too close still. We're in it." That sounds profound, so I nod, but secretly I think she's just saying that to avoid looking directly at anything now, in this moment. I especially don't know what it has to do with Doja Cat.

The word "webinar" begins to trigger a mild headache behind my left eyebrow. It is everywhere promising wellness, reflection, skills. Connection. "Webinar" is a stupid term and I hate it. Some words do not need the Modernity Treatment.

I have not been able to journal directly about anything for six months. I have nothing to say. I am briefly jealous of Anne Frank, but then overcome with guilt because she was confined to an attic, and then died, while the biggest hurdle I must overcome is sweeping my fabulous Observatory apartment. Then, buoyed by self-importance, I remind myself it's okay to be resentful of Anne Frank. Whatever gets us through the pandemic.

I begin to hate all of my friends and the near-constant rotation of video calls. Why do I have so many friends? I do not remember so many friends before lockdown, but they come one by one, haunting me, relentlessly demanding to know what series I've been watching to get through the days. One day, on a video call with a theatre friend who seriously wants to study the art of clowning, I halt mid-sentence and stay very still, hoping she'll think I have frozen and have a bad connection. I forget that my ceiling fan is still on, spinning round and round above my still head. It does not go over well.

When my mother calls to check in she is selfish about it. She asks me two questions — what's for dinner and how's the weather — and then launches into her own opera of disillusionment.

> *"I consider killing myself, more than once."*

Three times a week I am held captive by the dogs' latest escapades, my younger sister's mood swings and my mom's own anxious ramblings. These phone calls bring me no comfort. I have nothing to say to my mother, who is, at times, paralysed with fear. I cannot help her, my mouth cannot make the words to say that it will be okay. It won't work, anyways. I've tried to tell her already and every time I think she feels better, she finds something new to complain about — more laundry, more people without masks, more withdrawal symptoms because her nightly vase of red wine routine has been disturbed. I grow tired, annoyed. I snap. Twice, I lie and say I am expecting a delivery, that I have to go. I feel guilty, and resolve to try harder. She calls two days later and it's worse.

I consider killing myself, more than once. Not out of depression or a desire to escape any kind of overwhelming terror. Out of sheer boredom. Suicide and COVID denialism seem to be the only way out, and I want to escape with the least amount of collateral damage. I have thought about this.

On a particularly bad day with my anxiety-riddled roommate, I lie and say that we need toilet paper. I wait until she is in the middle of her work for the day and then tell her, reassuring her that I will go out and get some, not to worry about it. I leave, walk two streets down, find a tree and sit under it for thirty minutes. It is bliss. When it is over, I walk quickly to the Clicks down the road, buy a nine-pack and make my way back to my apartment. When I get back, she asks why it took so long and I say there was a long line, they had to limit the amount of people in the store. She asks if I'm sure I didn't touch anyone or anything, does my throat feel tight, am I lightheaded, how's my sense of taste? Feeling cruel, I tell her I'm a bit dizzy and want to go lie down. Frantic, she sanitises and heads straight for the MedLemon. My retreat is not even worth it.

All over the Internet, I am attacked by messages of positivity, solidarity, community. "We must come together, fight this thing as one!" the world seems to maniacally chant. Everywhere, I am encouraged by acts of kindness, foundations that start up to help the worst affected, friends taking up the mantel of social justice, making change. And even as I am inspired, I sink further and further into myself. I don't want to talk to anyone, I don't want to comfort or be comforted. I am constantly annoyed, having developed a temper that can only be a result from six months of isolation. I am more impatient, quick to anger and so sarcastic that I don't even know how I feel anymore. Every time I enter a grocery store, I must resist the temptation to bark at the elderly woman behind me to keep her distance. Every time my roommate asks me if I've noticed her coughing more, the urge to snap back is almost insurmountable. I gossip in a way I haven't done in years, relishing in nastiness. I am bitter, harsh and cruel. I am surviving a pandemic.

Years from now, when my friend finally talks about how important this all was, I will be sure to tell her this. That, at the worst of times, when the crucible supposedly showed the best of humanity, with frontline workers and food aid volunteers stepping up to be the shining examples of what community looks like, there were those of us who could not keep up. There were those of us, exhausted at the prospect of living through our first global disaster, that gave up on community, grew exasperated at the futility of our comforting words and shrugged off offers of support. She will pretend she does not know what I am talking about for a while, but after a couple of mojitos, she'll come clean, sheepishly recounting her own quarantine war stories. And it is this shared knowledge, not the unhinged performances of positivity, that will comfort us; the knowledge that we showed the worst sides of ourselves in the pandemic.

by Murray Hines

fortune cookie :(

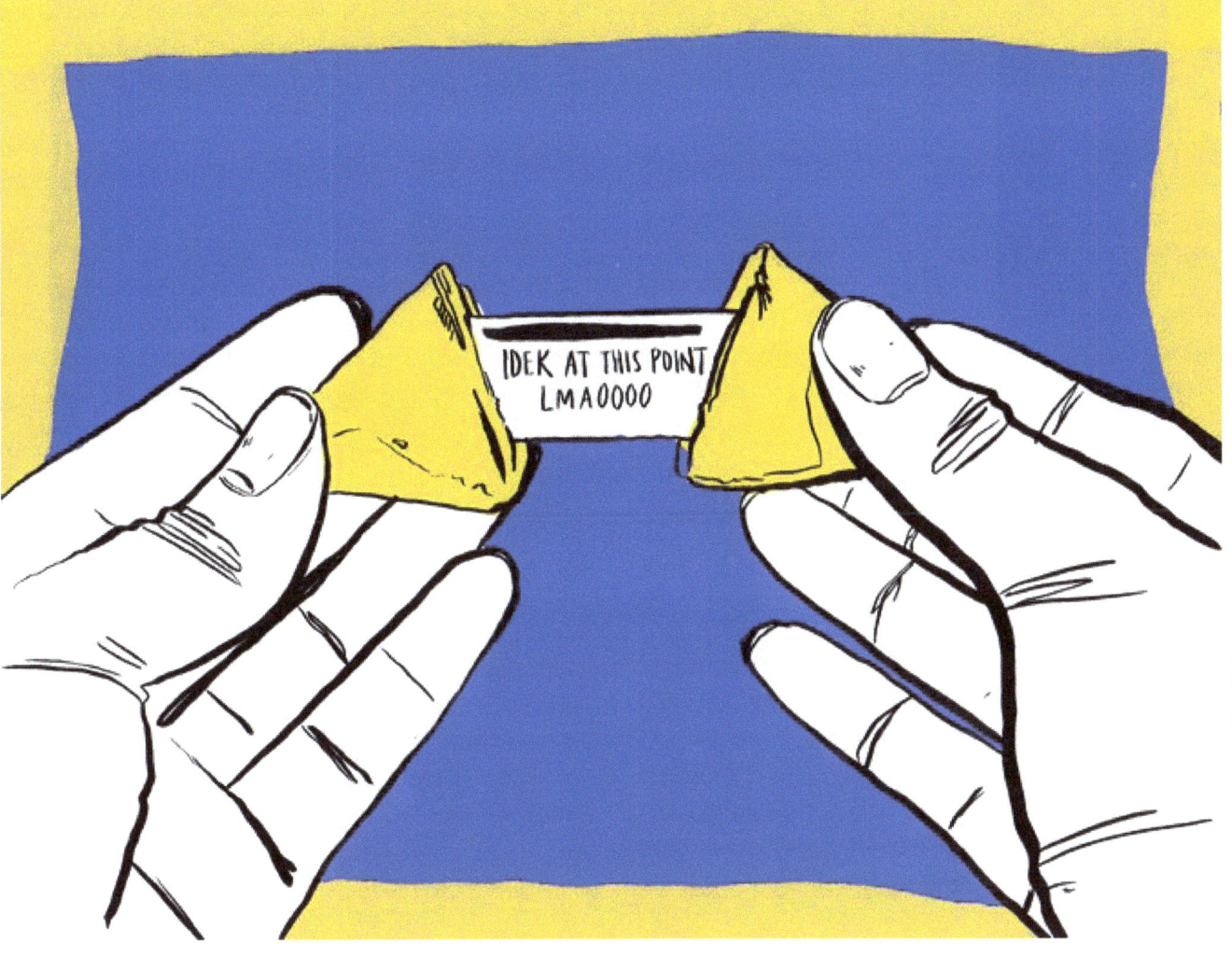

by Madison Bartlett

Dumpster Fire

How do you fix broken, shattered glass when all the pieces are scattered to the wind? How do you clean up an oil spill when its slick darkness infects the water, farther and farther down? Nope, start again. I can't do it with this with poetic shit.

This year was bad even before it got worse. My grandpa died in March. The cancer came back. He was tired of fighting. I'm tired of fighting, too. Why did he get to leave, but I have to stay? My grandma had a heart attack the morning of his funeral. My antidepressants stopped working. I couldn't get the dose upped until months later. By then, my extreme mood swings had returned and I bounced like a pinball between fury, desolation, and complete nothingness.

Isn't that an oxymoron; complete nothingness? I feel completely nothing. This year is almost complete, but it's been a vacuum of nothing and everything. I couldn't tell you what I was doing in the month of April, but I could tell you every shitty event that has happened between then and now. COVID, obviously. Black Lives Matter, again. We did this in 2014, and yet police are still killing innocent black people, six years later. Murder hornets. Where did those guys go? Australia on fire. California on fire. The Beirut explosion. Ruth Bader Ginsburg died. The resulting domino effect of political power grabbing. And we're only 75% through the year. There's an election in a month that decides whether we get back on track towards a democracy or slip further towards fascism.

Today is sometime in October, or also the 218th of March. Time has stopped since then. I didn't change out my clothes from winter to summer. Not that I needed to, since I was constantly inside, within the same four walls, day after day after day, until the days became blended as well. The only indication I had of time passing was my next assignment deadline. Eventually, the warm weather faded as well. My wardrobe was back in season, like summer never happened. It was like when you forget to change a clock for daylight savings time for so long it eventually tells the right time again.

Look, I can't be optimistic about this year. I can't say everything is going to turn out okay, because it's not. No one knows that. Anyone who says so is a liar and not paying attention. Our world is literally on fire; from climate change or a gender reveal party gone wrong, take your pick. It's bad, I admit. But I also can't throw in the towel completely. I'll admit I can't be all rainbows and sparkles about this year. But I can't completely ignore the few good things that came my way.

I celebrated my one year anniversary with my boyfriend. I started, worked, and left an amazing summer job. I turned twenty. My cat turned two. I started another semester. Time moved forward, regardless of how many waves of bad and worse news.

This year is a dumpster fire. Although, the one good thing about burning trash—you're getting rid of it. Hopefully.

Hindsight 20/20, I guess.

by Kailey Mgrdichian

self destruction is easier than self care

by Madison Bartlett

Comandatore

by Gavin McAllister

Circles of Silver

Granite smoke coils behind
foggy, glass doors of the furnace.
Immobile, for a moment, then ascending,
as grandpa exhales silver clouds
drawn from a corn-cob pipe,
reclining motionless by the fire.
The smoke from both
stretches their fingers for Heaven.

Gray hair crowns and cascades
down my grandmother's neck,
as withered hands strain
faded roots from the dirt.
Pearly sweat collects then falls,
watering the weeds she is uprooting.
The souls of both
still stretch their fingers for Earth.

by Benjamin Saloga

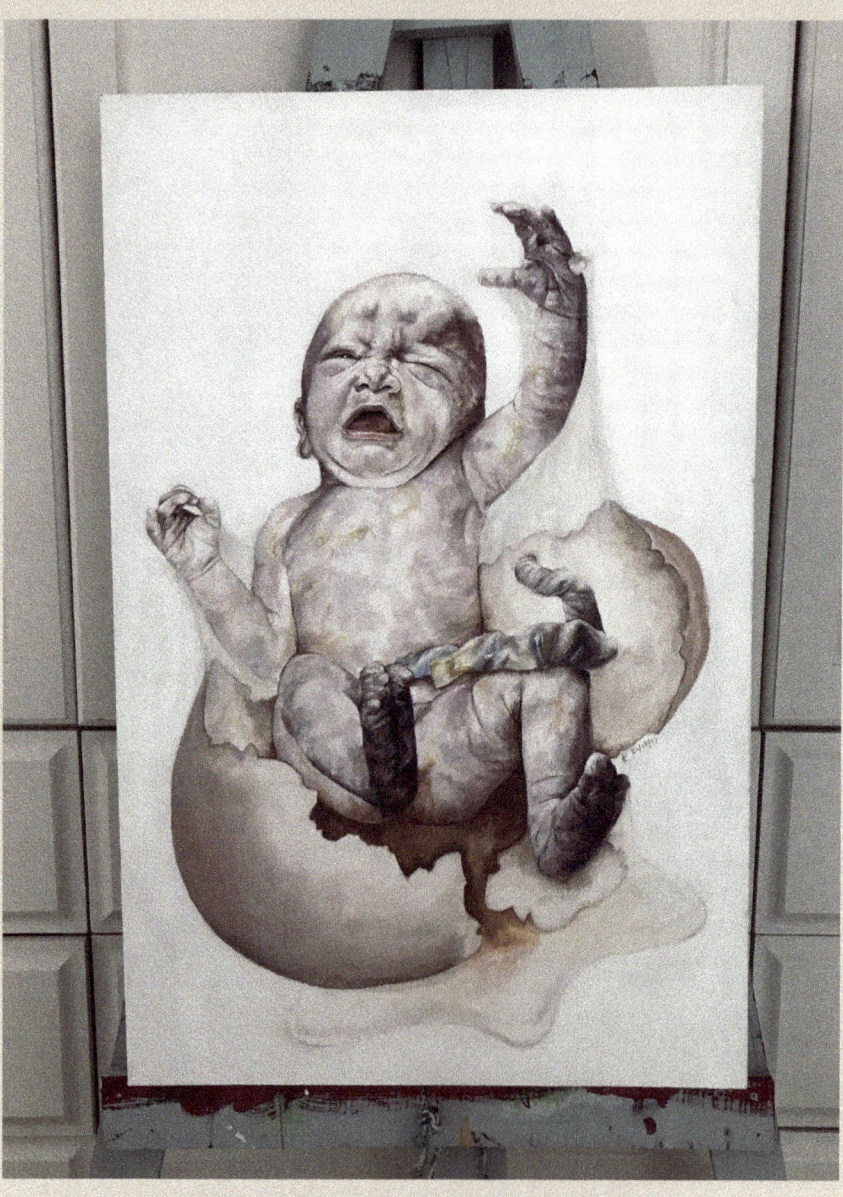

How We Should Be Born

by Kayleigh Hordijk

Little Woman

5:00 a.m. during a summer morning burns too bright for eyes, too sore for either light or darkness, and the head buzzes as it tries to understand that a whole new day has come to surface. The little woman arises after her early 2000s tone blares on her old flip phone at exactly 5:10, and I feel my heartbeat count each minute in drumming. I listen to her cough, brittle and violent, and the acoustic of every clump of mucus is accounted for in the air. And this time I listen to how long she waits for the water of her shower to get hot, as the house goes frigid past midnight for reasons unbeknownst to me and our seventy-degree thermostat. It's warm outside but my room, despite the seasons, drives everyone away. She denies it, but she won't come in even after she knocks on the door. I'm cold in here always, but I don't whine.

The entrance to my room is cracked just a peek beyond my comfort level, and two jagged lines of shadow fight above my piano against the wall, cast in a white block of light visible through the hallway. The light streams in from the bathroom because my mother, the little woman, evaluates her dentures with an open door, and then her eyes trail down to her mismatched sleepwear. It's a little loose on her body from years of wear when I was ten, as they were my clothes when I was young, and they carry years of neglect and like her are gently refolding. Slowly she hobbles into the kitchen, with her shuffling slippers helping me pinpoint her location, to check how much rice is left over from the previous day less devoured because we had banh mi. A Vietnamese sub, with bread so crisp golden brown, it blocked out the news with each of our bites.

She smacks and eats with blatant disregard; wide open, her tongue playing tag with the roof of her mouth. She talks to me about my body and my loves with blatant disregard. She sizes herself up in front of me with blatant disregard; a little woman feeling big, saying big things in the midst of being looked down upon by everyone else. Despite it having snowed in the middle of April, this little woman is deathly afraid of a spring breeze but not the permafrost sudden and prevalent in my room every time she comes in wordlessly to critique me. Her hands are thrown up and she knows what's best for her daughter. She doesn't have a favorite daughter. And acerbic as her voice is, loud and inappropriate for the indoors, she is my mother.

She's warm from the heat of the gas burner and anger swallows her without chewing enough times, but it chokes. She lurches inside the esophagus of wrath and her hand is always outstretched to meet my face, but not always violently. Her skin is wrinkled and callused from decades of working, under the myth that economic mobility was attainable. The heat of her hand follows me throughout college knowing that it burns itself on machinery, so I have a bed, and burns itself on cast iron, so I leave the house bloated in contentment.

These mornings where she doesn't know I'm awake, but I'm extremely aware of her, are the ones I feel the most remorse about. Hopefully she, just as well as I do, under-

> "These mornings where she doesn't know I'm awake, but I'm extremely aware of her, are the ones I feel the most remorse about. Hopefully she, just as well as I do, understands how easy dying could be for us."

stands how easy dying could be for us. And we wouldn't do it together, or exit harmoniously without bitterness and adversity, but we could weaponize it and continue using it as a threat.

"You'll understand when I'm dead," she says. Her favorite line over dinner.

"I wish I was never born, then," I say. My favorite line over fifth grade.

"It would have been better if you were never born," she retaliates.

With a smile, I point at her. "You'll be overjoyed when I die."

Anger is my least favorite family member; I never see them when the clock chimes at 5:30 a.m. I'm always so sad hearing how frail her footsteps are soft despite the weight of constant loss and frustration. Even with her ball and chain, she's a little woman, and sometimes I wonder if she takes them off when she sleeps.

We get along better in sleep, or at least when everyone else is. She says she doesn't dream; now that I've moved away and seldom see her, I doubt it. While her dreams are noiseless, monochrome vignettes of war times when everyone was still alive, and she could play big sister better than mine ever did, and she was thin and beautiful with a perm and a loyal, charming romantic prospect on bikes with sandals on. They're still dreams. And she has them.

Like getting rich and moving into a huge ranch style home without stairs. The weights are too much and groceries, a bad day at work, and the expectation of meeting eyes with me all prove too much. With a scowl, she asks how I'm home so early. I rectify it by uprooting a corner of the library and flipping it into my refuge until closing time. With a scowl, she asks why I wasn't more like my sister. I rectify it by uprooting myself, getting sick, and losing weight without notice, and I consider revisiting my childhood days of doing nothing but tracing her handwriting, her artwork, and the shape of her face to fit mine. With a scowl, she asks why I love our father more. In the coming years, I know I can't help it. Both have equal offenses, but I'm his kid, and I'm his youngest, and I'm his. What am I to my mother?

A slightly bigger woman. It's always important that—despite going to university, introducing my now ex-boyfriend, and achieving much in academia—I am small, or get smaller. Regardless of my broad shoulders and set gaze to ward off strange catcallers, I am small, and I feel it overtake me at 5:45 a.m. I am a little woman, and when I look in the mirror sometimes, I am little enough to be her.

She doesn't call me, and I don't call her. But this weekend, as I stay up past dawn once more and listen to how dejected every motion of hers is from the kitchen, I sigh in defeat and guilt. The most I can do is hope that her shower gave her enough warmth for the day. Little women, as we know, get cold so very easily and always are, but we don't whine.

by Leiz Chan

Untitled by Eva Long

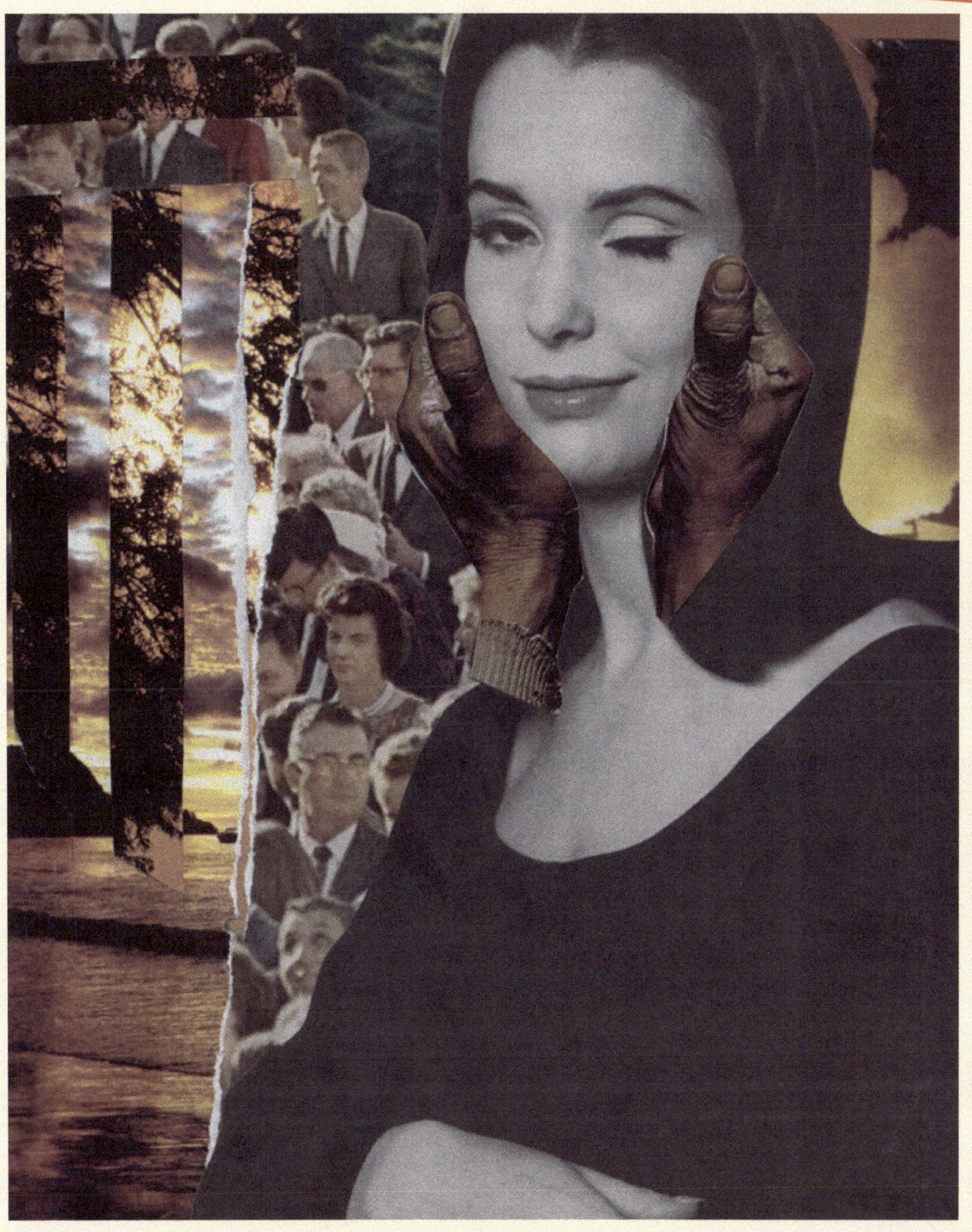

Private Show

She doesn't know why she keeps the mic on. No one is listening.

Outside the window, the gray sky rests heavy on the buildings. Suffocating. Like the final gasp of each casualty has stayed in the atmosphere. She can't imagine anyone listening amid all this. She must be keeping the mic on for herself, then. So she'll stay sane. So she can pretend there are people left to listen.

The commercial break is ending. The countdown on the last ad slips from six seconds to five—

She doesn't know why she keeps playing the commercials either.

—to four to three—

Maybe for a sense of normalcy. Nothing says normal like O'Reilly Auto Parts.

—to two to one—

"Welcome back," she says into the mic. She's perfected her on-air voice. Low but not too low, gentle but assured. She used to think of herself as an auditory lighthouse, her voice guiding the partiers and late-workers home in the night. That was when her show spanned across the midnight hours. She picked up the shift despite her friends telling her it was crazy—maybe because they told her it was crazy. There was something romantic about predawn radio, though, she thought. Broadcasting to nothing except maybe, possibly, perhaps a person also afflicted with insomnia, or coming into the city from a long trip, taking a drive and searching for some music, stumbling onto the college radio station at the left end of the dial and hearing a real person that was also awake. Sharing that moment without ever meeting. She liked to imagine her lighthouse voice giving them comfort in the dark.

Now she has all the hours, day and night, to herself. She still has her lighthouse voice, but she doesn't think there's anyone left to guide home. Not after this long.

"You're listening to 88.9, WERS, at Emerson College," she says, because it's the top of the hour, and the station heads make it seem like the FCC will personally bite her head off if she doesn't recite the legal ID every hour. Hours don't really matter anymore—neither does the FCC, or the station heads—but, like the mic, like the commercials, she does it anyway. To pretend things have order.

"If you have any requests, give us a call."

She recites the phone number by rote. It's lost the jaunty excitement that someone might call. No one has called in weeks. Just silence ever since the news announced that the country's population had been halved only two months after the first confirmed case.

"Coming up, I've got 'Private

Show' by Black Marble, and next—"

Her words hook in her throat. What is next? What could possibly be next? She was about to list the tracks she queued up in the CD player, a big boxy thing that holds three discs at once. The track timers blink at her. She had carefully added the minutes and seconds together, so the songs will bring her to the quarter-hour, and then she'll play the pre-recorded PSAs, right on time. That's the way her shows are: planned to the second. Does that matter anymore? Does she need to do it?

Maybe not. But it's all she can do. If she doesn't do something, she'll go crazy with the sheer emptiness of life now. She's finished what schoolwork was available, even after her professors stopped emailing back. The campus closed months ago, but there was nowhere for her to go. No one noticed when she moved into the station. No one was left to notice. The cafeteria kitchen in the building is stocked, the plumbing and electricity still work, so she's physically able to survive, if the loneliness doesn't consume her first.

The phone line lights up.

Her eyes snap to the flashing light on the left side of the board. It winks at her, once, twice, and she can't move. It doesn't feel real.

Three flashes.

Four.

Autonomy returns to her and she lunges for the switch that places the call on-air. She's supposed to warn a person that they're speaking live, but the prospect of hearing another human voice—real, alive—other than her own is enough to make her forego the process. She switches the phone line on and shoves the fader up as high as it will go, wanting to hear each word as loud as possible from the studio speakers.

"You're on WERS," she manages to say into the mic, despite her throat being drier than plywood. She wants this to sound normal, like any call into the station on any day, because if she treats it like it's normal, maybe everything will follow suit. Maybe the cities will come alive again, maybe stores will open, maybe she won't be holding her breath to listen to the only real voice she's heard in weeks.

"Hello?"

A gasp shoves its way from her chest.

"Hello," she says. It's such a beautiful word. "Hello."

The voice is low, male, though a pitchy crack turns his first word into two syllables when he says, "Oh my God." It's low, male, though a pitchy crack turns his "oh" into two syllables. A short, rasping breath over the speakers, and it fills the studio with static but she doesn't care. She closes her eyes as he repeats: "God. Christ. Hi. I thought the station was automated until I heard you, and I didn't even know if I'd get a signal anymore but—"

He coughs, a horrible, raking sound.

She reels back from the mic on instinct, even though she can't be infected through the speakers. Panic raps on a snare drum in her chest. He's got it. He's got it. The thing that's been felling populations. The thing that's brought the world to its knees. She doesn't know what to say. Her father died faster than they could quarantine him, and even if he had been in the hospital, she wouldn't have been able to visit him. Not even family are allowed in to see patients. There would be no funeral. That brought too many people in one place, the notifier said, sounding distracted by the hospital ambiance in the background, the echoed coughs behind him. She didn't have money to fly home, and traveling was a suicide mission by then, so she asked that he be cremated and held her own service. Quietly. Alone. She's gotten good at grieving alone. Her mother has been gone for years, her friends aren't answering her texts or calls. She knows they're gone too, and she knows this man will be gone soon enough as well.

"I don't know where," the man says, filling in her silence. "I mean, no one knows where they got it, right? But once I realized, I, uh, I started driving. I wanted to see the ocean again."

One second.

Two.

Three.

"Please," he says on the fourth. "Please, can you say something?"

She tries to keep her voice from trembling. "Yes. I'm here."

"I just—" His breaths come high-pitched and sharp, like quick violin strokes. "There's no one else. I haven't heard anyone in weeks and now—now you."

"Now me," she repeats quietly.
"I just wanted to talk to someone. I don't have—I'm not—I..."

They both know. They saw the headlines. The progression of symptoms, how much time a victim has. First the fever, then the chills. Uncontrollable shaking, difficulty breathing. Coughing up blood and bile and eventually choking on it. He sounds close to the last one.

"Do you want me to play a song for you?" she asks, praying he'll say yes and she can stop listening to his lungs fall short of their purpose.

"No," he says, fast. "I just want to talk to someone. Please."

She almost says she can't. Almost cuts the line. She doesn't want to hear someone die. But she wants to leave a man to die alone even less. Her father died alone. She couldn't make it to him, be there when he needed her, but she can be here for this man. Can't she? So she swallows and asks: "What do you want to talk about?"

"Anything. Anything but this."

"Okay." She keeps her eyes straight ahead, staring at the freshly painted studio walls. People started wearing masks before the chemical smell faded. "Did you get to see the

ocean?"

"Staring at it right now. Parked by a wharf."

"Good. Why...why is it so important to you?"

He laughs, which turns into a cough. "I grew up on the water. We had a sailboat, but had to get rid of it when we moved."

"Did you go out a lot?"

"All summer. You ever been sailing?"

She shakes her head even though he can't see. "No."

He sighs, and it almost sounds happy. "You can stand at the very end of the bow and grab the railing, 'cause if the waves are big enough and you time it just right, you can jump when the bow goes up over a swell. It feels like you're floating for a second. Like zero gravity. But it's only a second. And you just wait for the next wave and the next, trying to feel that forever. I spent hours up there, until my hair was all stiff from the salt spray."

"That sounds nice."

"It was," he says. "You know, it really was."

She tries to say something else, but coughing drowns out her voice. Deep, aching coughs, and the sound of something wet coming up his throat. Choking. She has to pull the slider down just to hear herself think, though she's not thinking much. She's just trying not to cry. It's taking everything she has not to hang up, but she can't let him die alone.

"I'm here," she says, then louder, trying to rise above the hacking: "I'm still here, you—you can tell me more about the ocean! How old were you then? What was the boat's name?"

She keeps asking questions, keeps shouting even though there's silence and all that rings out is her tinny voice from the headphones discarded on the table. She swipes away tears that make her fingers slip on the fader as she tries to turn it off, until finally the button goes red.

"I'm sorry," she whispers. The foam mic cover itches at her skin as she touches her forehead to it, eyes closed. Tries to find herself again amid the chaos.

What else is there to do? She raises her head and looks at the clock. She still has four minutes till the quarter-hour. Enough time for a song before the PSAs.

She turns back to the mic.

"I don't know if anyone's listening," she says. "But I'm here. I'm still here."

A deep breath.

"Here's 'Private Show' by Black Marble."

by Elsa Richardson-Bach

Grief in Eight Acts

1. I tell my best friend that if he died, I'd call his phone and sit quiet for seconds in the waiting room of the phone lines that will take me nowhere, just so I could hear his voice on the other line. My great-grandma leaves behind recorded radio hours, and I seek them out to make up for the six year radio silence. Sometimes, if I close my eyes, the skip of the Elton John record sounds like your laughter, like you listened to it so much the grooves in the vinyl became valleys for your voice.

2. I think about my own death as much as I think about sports or cleaning the inside of my oven, which is another way to say: not at all. I think about everyone else's death as much as I think about the right corner of his mouth and the bridges of Taylor Swift songs, which is to say: all the time. It is the most selfish thing about me, that I want to die before everyone I love, so I never have to get on a first-name basis with the absence, which is another way to say: my body has never been furnished with a good bone.

3. Losing someone is always poor timing; losing someone in a year baptized by the fountain of loss and grief means I've probably said something deeply offensive about the universe's mother, and this, this right here is the payback.

4. The armchair doesn't look the same after you die. I've only come home a few times since the last chapter of April, but I feel the emptiness of the chair all the same, like I live inside of it, like its leather longing tattooed itself underneath my eyelids.

5. The woman in the second pew of my church lost her son, and I noticed how her hair went from red to white lightning-quick. I noticed how her face aged another fifty years every Sunday. I think about how my grandma gets smaller every day since you died. I think about how grief is a world-renowned sculptor.

6. The tattoo of a ship on your right arm is my name twin, and Mom says you told her to make sure I knew its name was the same as mine, when she saw you for the last time. It is one thing to know you have been loved so deeply; and it is another thing entirely to be made so deeply aware of it.

7. When the headlines of this year do not cut deep enough, when the statistics don't seem real, I press play on a supercut of my own grief to breathe life into the black ink carving out the number of deaths; I take the 948,000 and paint them as 948,000 empty chairs, 948,000 armchairs turned into fossils, 948,000 living rooms that have become still-life paintings, paintings that a family flickers and floats through, nothing but brushstrokes. Somehow there is still life.

8. A few days after you die, my professor launches into a lecture about palliative care, and death, and specifically how the death of a grandparent affects a family, and all I do is laugh, because you would, and because everything about this year has felt like a punchline. But here is the answer, to how the death of a grandparent affects a family: the armchair is always empty, even (especially) when someone is sitting in it.

by Hannah Rose Showalter

ocean?"

"Staring at it right now. Parked by a wharf."

"Good. Why...why is it so important to you?"

He laughs, which turns into a cough. "I grew up on the water. We had a sailboat, but had to get rid of it when we moved."

"Did you go out a lot?"

"All summer. You ever been sailing?"

She shakes her head even though he can't see. "No."

He sighs, and it almost sounds happy. "You can stand at the very end of the bow and grab the railing, 'cause if the waves are big enough and you time it just right, you can jump when the bow goes up over a swell. It feels like you're floating for a second. Like zero gravity. But it's only a second. And you just wait for the next wave and the next, trying to feel that forever. I spent hours up there, until my hair was all stiff from the salt spray."

"That sounds nice."

"It was," he says. "You know, it really was."

She tries to say something else, but coughing drowns out her voice. Deep, aching coughs, and the sound of something wet coming up his throat. Choking. She has to pull the slider down just to hear herself think, though she's not thinking much. She's just trying not to cry. It's taking everything she has not to hang up, but she can't let him die alone.

"I'm here," she says, then louder, trying to rise above the hacking: "I'm still here, you—you can tell me more about the ocean! How old were you then? What was the boat's name?"

She keeps asking questions, keeps shouting even though there's silence and all that rings out is her tinny voice from the headphones discarded on the table. She swipes away tears that make her fingers slip on the fader as she tries to turn it off, until finally the button goes red.

"I'm sorry," she whispers. The foam mic cover itches at her skin as she touches her forehead to it, eyes closed. Tries to find herself again amid the chaos.

What else is there to do? She raises her head and looks at the clock. She still has four minutes till the quarter-hour. Enough time for a song before the PSAs.

She turns back to the mic.

"I don't know if anyone's listening," she says. "But I'm here. I'm still here."

A deep breath.

"Here's 'Private Show' by Black Marble."

by Elsa Richardson-Bach

Grief in Eight Acts

1. I tell my best friend that if he died, I'd call his phone and sit quiet for seconds in the waiting room of the phone lines that will take me nowhere, just so I could hear his voice on the other line. My great-grandma leaves behind recorded radio hours, and I seek them out to make up for the six year radio silence. Sometimes, if I close my eyes, the skip of the Elton John record sounds like your laughter, like you listened to it so much the grooves in the vinyl became valleys for your voice.

2. I think about my own death as much as I think about sports or cleaning the inside of my oven, which is another way to say: not at all. I think about everyone else's death as much as I think about the right corner of his mouth and the bridges of Taylor Swift songs, which is to say: all the time. It is the most selfish thing about me, that I want to die before everyone I love, so I never have to get on a first-name basis with the absence, which is another way to say: my body has never been furnished with a good bone.

3. Losing someone is always poor timing; losing someone in a year baptized by the fountain of loss and grief means I've probably said something deeply offensive about the universe's mother, and this, this right here is the payback.

4. The armchair doesn't look the same after you die. I've only come home a few times since the last chapter of April, but I feel the emptiness of the chair all the same, like I live inside of it, like its leather longing tattooed itself underneath my eyelids.

5. The woman in the second pew of my church lost her son, and I noticed how her hair went from red to white lightning-quick. I noticed how her face aged another fifty years every Sunday. I think about how my grandma gets smaller every day since you died. I think about how grief is a world-renowned sculptor.

6. The tattoo of a ship on your right arm is my name twin, and Mom says you told her to make sure I knew its name was the same as mine, when she saw you for the last time. It is one thing to know you have been loved so deeply; and it is another thing entirely to be made so deeply aware of it.

7. When the headlines of this year do not cut deep enough, when the statistics don't seem real, I press play on a supercut of my own grief to breathe life into the black ink carving out the number of deaths; I take the 948,000 and paint them as 948,000 empty chairs, 948,000 armchairs turned into fossils, 948,000 living rooms that have become still-life paintings, paintings that a family flickers and floats through, nothing but brushstrokes. Somehow there is still life.

8. A few days after you die, my professor launches into a lecture about palliative care, and death, and specifically how the death of a grandparent affects a family, and all I do is laugh, because you would, and because everything about this year has felt like a punchline. But here is the answer, to how the death of a grandparent affects a family: the armchair is always empty, even (especially) when someone is sitting in it.

by Hannah Rose Showalter

2. *Do you think stars get lonely?*

3. *Do you think Merry Clayton gets lonely?*

I like "Gimme Shelter." It's a good song. It's very emotive. Merry Clayton has the best part. I'm glad Merry Clayton sang that song. Maybe if she hadn't, she wouldn't have had a miscarriage. Therefore, I'm glad Merry Clayton had a miscarriage? I'm glad she sang the song.

4. *Does that make me a bad person?*

I don't want to be a bad person. I don't want to be a star, either. Stars are always exploding. I want to be a Rolling Stone. Stones don't explode. Stones are cool. Stones are solid. Stones don't get lonely. Stones don't get anything. Stones don't have feelings.

(Answer Key: 16, probably, maybe, if Merry Clayton = star then who are you?)

My doctor says I can't be a stone. My doctor says get off the floor. But I can't.

I am listening to the Rolling Stones.

by Meg Mechelke

"Everyday Saint"

Art By: Natalie David

To Rest On Concrete

For the kid holding a hand-painted poster that said "if I die in a school shooting drop my body on the steps of the CDC."

She will reach into the crevices of her eyes, extract pearls from oysters, and blow them from her fingertips like dandelion heads. The wind will mistake them for seeds. Sleep will become something that is planted in the late April grass and grows annually like the lull that comes after Easter is over.

She will wait to shave her legs until the last possible minute, cradle calf over bathtub, and sing "Sunday Bloody Sunday" because she is never as careful as she thinks she is.

She will leave in the morning and forget to close the garage door behind her. She will circle back, walk along the cut-through streets to make sure she left things as they should be. No one will circle back to make sure she is left as she should be.

She will fall asleep in public three times before 9:00 a.m. She will imagine the bus commuters as ants each carrying pieces of fruit larger than their bodies. She can see the way their shoulders are sinking. She will wish to double grocery bag their troubles and chuck them out the bus window.

She will think that public transportation is a collection of people who are airing their dirty laundry out the open windows. Who are not too bashful to apologize for taking up space. She will think of the woman in the wheelchair with an orange silk scarf as a monument. The fabric as lady liberty's torch. She will wonder when the fire burned out.

She will ask herself if she is fiction or nonfiction. She will never truly know. She will not get to decide for herself what is real and what is not. She will have it decided for her; will walk into brick buildings and sit in plastic chairs and learn not to question if she will get to walk back out.

She will jut her chin. She will practice for when she is in the world. She will have a pokerface and listen to her heels click on the sidewalk. She will see her face reflected in the stained-glass windows of the cathedral. She will put her faith in the public education system the way old people reach their hands up in

> *Seeds will be planted and plucked and cursed out of luck and will not quite make it to May.*

church: assured and inhabited by a certainty of afterlife.

 She will miss the last step on the capitol building stairs. She will view everything that feeds luck as a symbol of retribution to her anger. She will view everything that defies it as a spell cast by those who wish to find her body dead on the linoleum floor.

 There will be no wake-up call. Seeds will be planted and plucked and cursed out of luck and will not quite make it to May. She will not rise three days later. She will not become monument. And her absence will be as loud as it is invisible; fleeting with no object permanence. This will happen again. We will forget again. We will wake up in April and much too quickly go back to sleep.

 People will not be seen as insects. Oysters will not reach their time to harvest. There will be no one to recycle the grocery bags layered on her living room floor. They will not be cut up and woven into blankets. A softer place to land will not exist. The world will revolve around the woodwork underneath. She will not see the earth transform. Wood. Paper. Dust. Rain. Evaporation. Wind. Seedling. Tree.

 We will not sing "Sunday Bloody Sunday". The church choir will not sing at all.

by Amanda Pendley

haiku #25/05

black lives matter and
i cannot breathe have the same
syllables to gasp

by Ciara Flashman

Blue and Pink Make Purple

by Nicole Adams

I was fourteen when I hesitated. It was minutes before heading out to eat with my parents. I had just showed them the poster my friend had made to ask me to the freshman spring dance. It was girl's choice and a girl had asked me to the dance — no wonder they had questions.

Joanna is bisexual? Yes.

Does she like you? No.

Is this a date? No.

The answers I knew they wanted flew off my tongue as soon as their questions touched the air.

Do you like girls?

And I hesitated. One brief second of uncertainty and a void yawned open. I was stuck, staring at my father, at a loss for words. At a loss for thoughts. I hadn't meant to pause. I hadn't meant to open up a pit of anxiety and confusion and uncomfortable conversations. I sat there in that hesitation, mouth agape, mind blank. Across the dining table my father's eyes bored into mine. My mother stood frozen in a kitchen, as if she were afraid to move until I spoke.

I didn't have an answer for them. I was their boy-crazy little girl. At two years old I played wedding over and over with my first crush. He had spiky blond hair and we held our chubby hands together in phony matrimony. In elementary school I would rush home breathless to gush to my mom about the nerdy boy with bright eyes who'd held my hand on the bus that afternoon. My brother's old Brett Farve action figure kissed all my Barbie dolls. My mother never noticed the subplot of my stories, where the main Barbie's friends would touch their plastic lips to one another. Or how they'd wrap their arms around each other, my mind melting the stiff plastic into a loving embrace.

I didn't know why I got butterflies on the way to religious education classes the year prior. It couldn't have been because of my friend with reckless curls and a cinnamon smile. She was loud and witty. And we shared the grins of co-conspirators, reading each other's sarcastic thoughts as the priest droned on. All I knew was that I wanted to lean my head on her shoulder—on that pillow of cocoa curls—and that this friendship felt different than others. That old Catholic church basement held the beginning of something euphoric. I just didn't know it yet.

At fourteen I didn't know that in the coming years I'd become entranced by the girl with the Disney princess smile, or the woman with fire in her eyes. I didn't know of the war that would battle in my

stomach over the boys I'd want to hold me versus the allure of the soft bodies that girls had. The opposing armies forcing me into fits of nausea when my thoughts lingered too long on the subject. One army using curves and subtle glances and pink lips as the offense; the other side chose sweeping romances of the books I adored and the argument for a simpler life as a defense. I didn't know that the war would settle armies merged into one on a winter day when my drama teacher explained the color purple.

I didn't know yet that in the three years following my hesitation I would have to tell my parents that I felt "perfectly straight." My father confirming this answer almost monthly. Instead of facing that agonizing conversation I told them what they wanted to hear. Until the day I stared at an

ajna

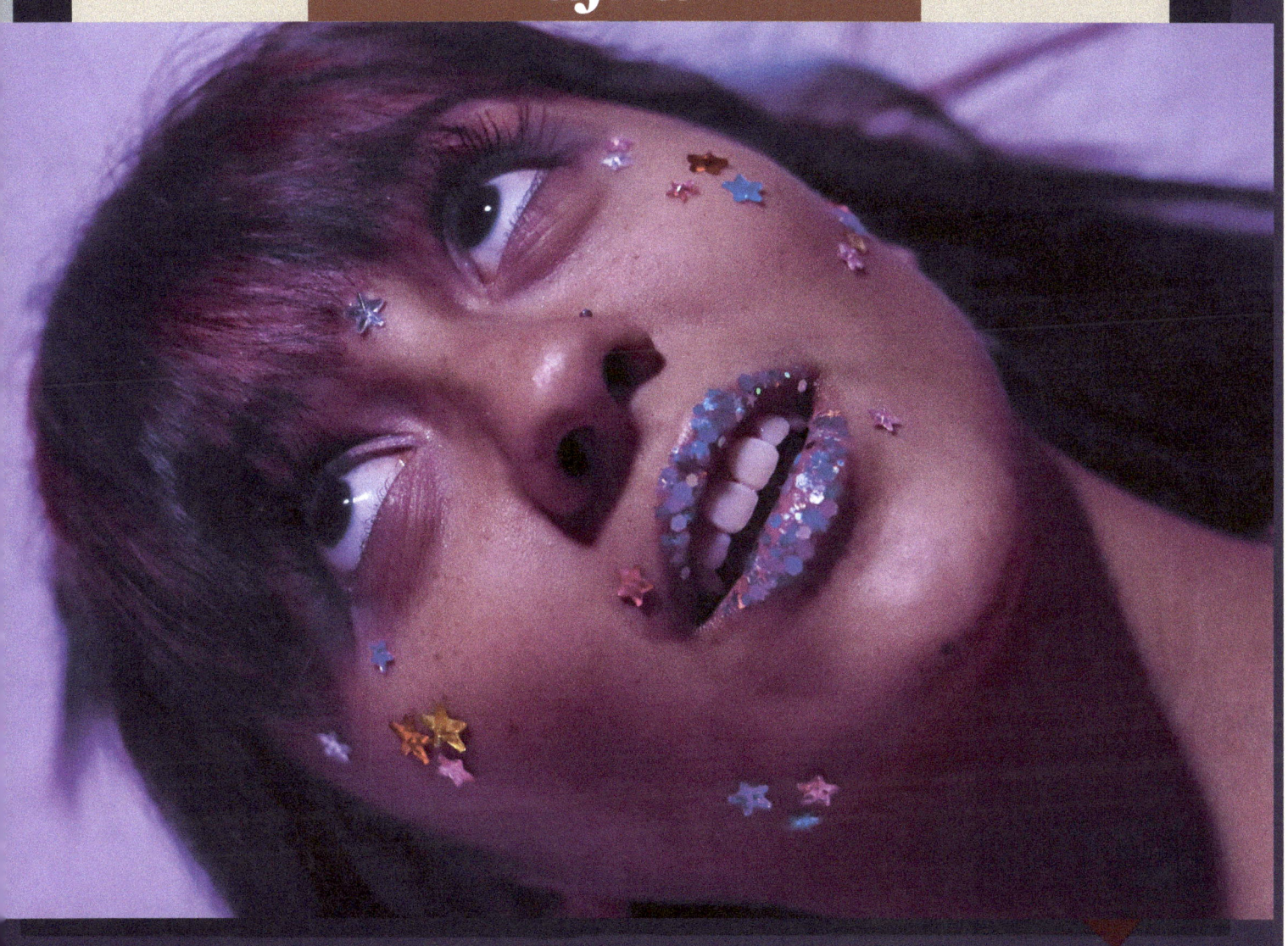

Jax photographed by Betsy Smith

orange popcorn bowl instead of my mother's eyes and told them I wasn't "perfectly straight." I didn't know the way my stomach would plummet through the floor when she said she didn't buy it.

I didn't know that weeks after admitting who I was, one of my friends would join me in this confusingly exquisite existence—that we'd figure it out together, forging a bond even deeper than the initial one based on ice cream and the arrogant boy we both liked in ninth grade. I didn't know that senior year I'd be cast as a lesbian in the play and hot tears would stream down as all my castmates embraced me. I didn't know I could feel so at home with who I was.

I didn't know that in the dark basement of a frat house I'd see a beautiful girl, the only girl at the party in a flannel shirt, and end up with her lips on mine in the middle of the dance floor. I didn't yet know how smooth her lips would feel, how I'd run my hand through her hair as she gripped my face, about how everyone in the room would watch, entranced by us. I didn't know how my heart would throb throughout my body and that I wouldn't be drunk on the shitty jungle juice but rather drunk on the freedom and power I felt while claiming myself and her lips in fluid motion.

I didn't know any of this at fourteen as I stood in the dining room across from my father with my jaw hanging open and no words coming out. So, I closed my mouth and looked down at the handmade poster laying on the table and ran my fingers over the shading of a yellow colored pencil. I took the deepest breath of my life, met my father's eyes and answered his question.

windows

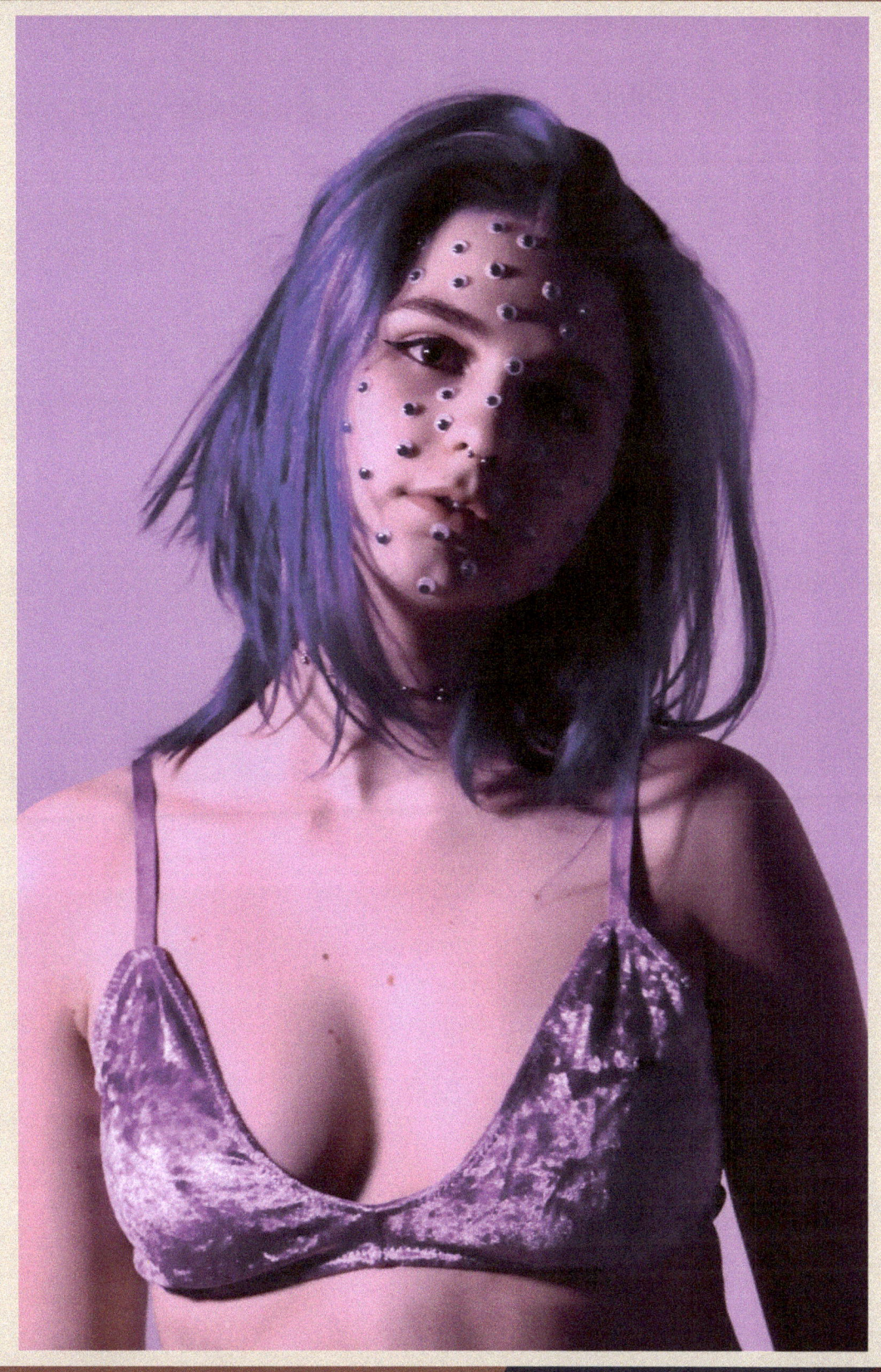

McKenna photographed by Betsy Smith

rebegin

wind up toys mimic ballroom dancers/ swaying into the arms of lovers that they will later/ take for granted/ leave shoes behind/ and run barefoot/ on blackened callous/ flipping through street names like storybook pages/ going back because you forgot what you just read/ and can't seem to retain/ hold captive/ let me pay ransom to clutch onto the good parts of us/ I am flailing into the arms of strangers/ hoping they will have the decency to care for a girl who's forgotten her own name/ but remembers how to waltz/ how to rewind and/ reach inside her own ear and hear the churn of the vhs tape/ to always depend on the sound of things to determine if they are good enough

to hate the sound of her own voice/ to not recognize it on interview audio transcriptions/ to hear instead the scraping of blades on the ice/ to remember how J taught her how to skate/ to remember her mother crying when she found out that he used to drive his daughter and I to pepsi ice while drunk/ and blaming herself because/ no one ever taught us what the word drunk meant before it was too late

we just thought he was happy/ and that when he revved the engine a little too hard/ it was just because he liked the sound it made/ that he liked playing truth or dare with the red lights/ that he would do u-turns where u-turns weren't meant to be done/ to teach us what it meant to

retreat/ to circle back/ to foreshadow/ to forget where you emerged and get so lost in yourself that you forget there are/ two girls in the backseat/ that when you shut a car door/ it should serve as an announcement that you are here/ slam it as exclamation

let him tie your skates so tight that your toes lose feeling/ let him drag you both/ a girl clinging to each arm/ as he would attempt to sprint/ take to the ice so fast that you forget that life doesn't exist in fast forward/ he would hurl himself forward/ pulling the two of us like clumsy suitcases/ and propel this manmade unit into the blank space/ let us go and watched as we went by/ flying/ sailing/ shrieking as we learned the hard way how to turn so that we wouldn't end up crashing

how we would ask to do it again/ to restart/ to unravel/ to wind up/ to get caught up in rebeginning/ so that the release would come again and again/ where we felt relieved from the weight of our coats/ and the stones hidden in their pockets/ until we were left in tank tops/ freezing and freeing ourselves/ becoming

by Amanda Pendley

ON A THURSDAY, MY THERAPIST ASKS
after José Olivarez

what are you afraid of?

one day, someone will be stuck
in traffic arguing on the
phone with their lover & the sun
will incernate their earth.
the sun wouldn't even ask.
the sun is a gemini like that.

what are you afraid of?

my mom calls, then forgets what she called for. i try
not to build a story that ends in me being alone.

what are you afraid of?

that i will spend the next forty-five years digging
into the same soil, looking for a new set of
bones to imprint my hips with. it always ends
with the lover leaving.

what are you afraid of?

growing up, my grandpa had an orange tree
i searched for the most rotten ones

to throw at my sister.

what are you afraid of?

there is a head
of garlic in the cabinet
above my ex-girlfriends sink. i know this
as a universal truth. it's been a year
when i hear she gave up
her apartment by the water.

what are you afraid of?

the australian asks where i'm from & i finger
the thread of the hostel sheet. i think of
 san francisco first. then, an '02 minivan
parked on a dirt hill, beer bottles in the trunk
overlooking the city. i'm not sure which answer
makes me more of a liar.

what are you afraid of?

ultraviolet fingerprints on my arm.
men with fingers.

what are you afraid of?

that my window screen will give way
too easily when met with a knife.
i fall asleep with it open anyway.
mostly, i don't have the energy to fix fear.

what are you afraid of?

am i talking about what i should be talking about?

what are you afraid of?

my wanting:
a lemon tiled kitchen, soft hands, my body
becoming more & more
forgetful.

by Sydney Vogl

Untitled by Eva Long

Content Warning: Eating Disorders

Dimmed Lights

Shmmacck! Shmmacck! Shmmacck!

The sound of my dance professor clapping her hands together echoed in my ears. The sharp sound reminded me of gunshots at a horse race. Filling my lungs with one last breath, my shoulders drew back, and my feet pulled me forward into the combination. Today's combo consisted of a movement where we settled into a full squat and proceeded to march in circles around the gymnasium smacking the pads of our feet on the ground in an awkward gallop.

I could feel the bottoms of my heels collecting the dust, dry skin, and hair that littered the floor, but I was too focused on catching her eye. For the past four weeks leading up to finals, my professor had ignored me, barely making eye contact with me.

I was used to being invisible in a room of skinny, long-legged ballerinas: the romantic arch in their back, the simple, elegant extension of each leg, the way their thin fingertips barely grazed the air. No matter how I moved my body, it was just a fact, my visual lines were inadequate. When my professor finally saw me she looked at me with glassy eyes. Eyes that held no sign of interest. Eyes that told me she could see right through me.

My conscience rotated through the comments I had heard on repeat for the majority of my life reciting the verses perfectly. *Don't eat so much... you'll never be able to get your ass off the ground. You've got man's legs. Guys would never be able to partner with you. You're a dancer? Oh, I definitely thought you were a gymnast.* Then my mind formed its own questions. *Why couldn't you just be light and graceful as her? Why couldn't you move like them?*

I continued to march across the floor with three other dancers shifting my eyes from my professor to the ground. Each mental insult seemed to pile up on my shoulders forcing the false confidence to slowly bleed out of me.

It all began in high school. All 14 girls in my ballet class would stand in front of a wall of mirrors only in sheer pink tights and black leotards. Every contour of our body was outlined, and we would spend those next three hours sucking in our stomachs. Our teachers would tell us it was important to be narrow, like a piece of toast sliding into a toaster. I'm not sure when, "tuck in your tummies little ballerinas!" became, "suck in your gut," but from the age of four and on, dance teachers were more focused on jabbing their finger into the belly flab on your stomach than instilling even a little confidence in us.

I consider myself fairly lucky compared to certain girls in my classes. The owner of my childhood studio took up the ritual of shaming her own stepdaughter calling her, "chubby like her father," in front of the entire class. The stepdaughter began to drink herself unconscious and was kicked off the team before we'd made it through our freshman year of high school. I moved studios my senior year, and even at this larger more progressive studio, the teacher would remind us that the dance industry valued looks over talent.

When I arrived on campus, I soon realized I had not left that culture behind. Professors and graduate students were known to only cast dancers who were a size two and below because, "the body

lines looked better."

My breaking point came during one graduate student's final project. I was sitting in a section of the auditorium with a large number of students and faculty when the woman strolled onto the stage. Her body was wrapped in a white duct tape bikini and she had a cowboy hat placed over her forehead. The woman began twirling and spiraling her body in all directions, every so often screaming into her hat. Her shoulders were tense, and she seemed to spasm and jolt her body every time she began a new segment of movements. A minute into her piece, the woman jolted so hard that one of her breasts slipped out of the duct tape bikini.

I sat deadly-still, my stomach twisting in horror. *This poor girl*, I thought. *She's been expos—* The woman continued to create intricate circles on the stage as the duct tape slid further and further down her body until she was standing stark naked in front of the crowd of faculty and undergraduates. The white tape sat in a pile in the middle of the stage, and she continued dancing.

She chose to expose her body, reclaiming every part of her. She valued the strong, powerful limbs the universe had given her, and it showed in the way she moved, using her muscles to push her up and across the stage. This graduate student did not see her body as a burden but rather a tool to her success as a dancer, a key to something new and unrecognizable from the current standards of the dance world. She bowed, put on a black robe and joined the rest of us in the audience to watch the next piece.

I wish I could say she opened my eyes to the possibilities, but I knew I could never bear what I considered the most sensitive, hidden part of myself. My body had been claimed. The bruises on my knees from kneeling over a toilet and the hunger pangs ripping through my stomach told me I had lost the fight. It was too late, and I had let myself fall too far. I had dedicated almost fifteen years to dance, and while I loved the art, the feeling would never be mutual. For my own sanity, I needed the voices to stop. I sent in my withdrawal from the dance program within the next week.

This sudden decision to amputate such a large part of my life caused me to spiral. I sent myself to therapy almost immediately after winter break; I was fragile yet self-destructive. I was a shell that would softly crumble into a pile of dust if anyone accidentally brushed against me. A fresh new page waiting for me; a fresh new life not defined by my physical appearance but by real talent. I spent the semester holed up in my single dorm room when I wasn't in class or in therapy, slowly inching my way to a version of myself that could actually be happy and fulfilled without dance.

A year later, sometimes I still lock the bedroom door and turn off all the lights. I let my body settle back into the ballet lines and the pirouettes I had known my whole life. Slowly lifting my leg into the air, I'll feel that same familiar force both pushing and pulling my body into a perfect arabesque. My eyes latch onto my figure in the mirror...and I smile like I have not done in years.

By Grace Culbertson

dreams by Kahill Perkins

I have always measured time in dreams or in sleep patterns and lately time

Has become stuck in I have always measured time in dreams or in sleep patterns and lately time

Has become stuck in nightmares and 3am bedtimes, revised by prepackaged margaritas.

Lately the dreams have been nightmares, garish things I do not wish to dredge up but may have to.

I dream of my dead grandfather, except his death becomes a hoax, he created because he was tired of me.

I dream of every person who has beat me, raped me or spit in my face except their face is that of my lover.

I wake up sobbing and my mouth guard is full of blood from my split lip timelines.

I dream that my father is dead, that he left me alone in the world, sometimes it's my sister or my mother. Never my brother. That I am unsure of.

I dream that my boyfriend's ex-girlfriend has locked me in a box and thrown it in the Kansas river, and that they are holed up in our bed room watching the princess bride eating my gluten free crackers.

 That she stole my favorite shoes and my hot pink venus earrings and posted them on her Instagram, I dream that she burned our house down with me in it and she stole my fucking dog. And then she killed my fucking dog.

Sometimes I do not dream at all, I just lay there next to my boyfriend and listen to him breathe and my mind tells me that I should definitely go through his phone and that he totally is

sending dick pics to like the next-door neighbor or some shit, except his phone is broken but so is my brain.

Last night I dreamt I sent a naked picture to every one on my phone accidently and someone named Alan sent back a video of him touching himself except his penis was a literal octopus, and I do not know anyone named Alan.

Sometimes I close my eyes and I see our smallest cat get cut in half by our

shitty heavy windows that don't stay open right.

I don't know what causes me to be unable to have good dreams, I do not remember the last good dream I had, I honestly have never seen beauty when I am asleep and yet here I am.

Tired, sleeping, scared in the dark, my fears going up and down and over and over through my ears and nose.

Sometimes I stand in the shower, and rest on the tile, letting my body catch up to my brain and its over active fear.

and 3am bedtimes, revised by prepackaged margaritas.

Painted Doors, Shuttered Windows

Art by Kyler Johnson

july
by Luna Phalen

july is the biggest room i've ever stood in,

full of desolation and waiting and waiting

and waiting in the dark heat.

my real self watches from the moment when leaves fall,

unable to cut a door into summer's glut.

they wouldn't help if they could anyways,

i can feel the beginnings of their saying

this pain was a gift

inside my own mouth.

so i'll wait july out,

find salvation in the ceiling fan

above the bed tomb i'm rotting in

(it spins and spins like the same day over and again),

or something.

One With Nature

by Megan Dobson

Vaseline

The sun is peeking out from behind low clouds, watermelon-pink on the far horizon. There's a long line of us here this morning even though I tried to be early. It's bitterly cold and my skin is chapped. I pull a small tub out of my coat pocket. Vaseline. I love the smell of it. It smells like home, but not now-home, the home I used to have when my parents were alive. Every time I open the tub, I like to place it beneath my nose, just for a second, so that I can smell her again. My mother. Beautiful, tired, but always smiling. My mother. Putting on her work clothes after a morning bath, swift towelling off, and, last, but not least, Vaseline. It made her skin shine like a glossy apple, the kind of apple you only see in adverts on TV. Fresh, polished, vibrant. Full of life. But she wasn't.

Today I can't lift the Vaseline to my nose though. I don't have that luxury. I'm standing too close to too many people and I'm wearing my mask. It scratches my nose as if it knows that I want to smell the Vaseline. *No big deal.* I dab some Vaseline on my palm before closing the tub and then rub it along the runnels of parched skin. *I remember you, Mama.* There's little solace in this world beyond my Vaseline, that smooth, slightly sticky petroleum jelly.

Gogo is doing her best looking after me and my brothers but without school, the days stretch on forever. The same cold, the same long walk to the water pump every day, peering out from the top of my homemade mask to see if everyone else is wearing theirs. There's always some obnoxious man who's not. Usually the same guy that likes to linger round the pump, smoking his contraband cigarettes. He can get you anything you want, I know. Even overseas brands. And now that liquor's been banned again, his business is even better. Thembu told me she bought five litres of potent beer from him. I don't trust this guy. I don't drink a lot, but I know beer isn't very potent. Whatever he's selling, it's not beer.

I get to the pump, finally, and fill my two big plastic bottles with water. I follow a slow-moving line of women carrying water on their heads and babies on their backs. I never learnt the trick. We used to have running water at home and now I'm too old to learn, too scared of spilling. Gogo teases me and says it's because I'm scared of damaging my brain. Book-smart, not life-smart. It sounds bad when you put it like that, but I know Gogo is proud of me. She thinks I'll go far. Like she hoped my mother would.

> There's little solace in this world beyond my Vaseline, that smooth, slightly sticky petroleum jelly.

In the cold, I watch my laboured steps. I listen to the footsteps and chatter of others. I heard on the radio about the girl in Soweto who was raped on her way to get groceries. 14 years old. I don't want to be that girl. My father gave me a pocket-knife when I turned 11 and the men on the construction site across the road started giving me looks. I have it with me, next to the Vaseline, just in case. Better to be prepared, Baba told me.

Baba. Baba with his woolly beard and too-loud laugh. Too-loud talking voice too. I used to hear him on the phone speaking to his family in Zim—shouting, as if to make up for the long distance. I wanted to tell him phones didn't struggle with distance like that anymore. I never did. It was hard enough for him being an immigrant. People don't like you when you're different. His shop was looted and set on fire. We had to move. He got a new job in the mines. And Mama sent him off with a *skaftien* early every morning.

I get home and Gogo is scolding me for taking too long. She's been waiting to heat the water. My brothers are complaining they're hungry. I sigh and make them some mielie meal and tell them there'll be tea soon. I want to offer them a rusk, but we don't have any.

Cyril announced last night that I can't go back to school, not for another four weeks. The Matrics can go back after one week, but not me. No one cares about Grade 11. I'm trying to study at home. I've read all the books for English and Zulu. I've been doing exercises from the Maths textbook. Thembu comes and works with me sometimes. I make her wear her mask and we sit outside on the grass, apart. Thembu thinks I'm crazy. I've had enough of these viruses though. The last time, there was so much anger and suffering. Mama screaming at Baba. *How could this happen?* I was too young. I didn't understand. And then Mama couldn't work anymore. She was too sick and tired and even the Vaseline couldn't make her skin shine like it used to. And Baba, he was worse. Our house smelled like shit and death.

Gogo comes back from her bath. She laughs at me because I'm still wearing my mask. I take it off and feel the dryness of my lips. Gogo's eyes are big and round, filled with all the hopes and dreams she never got to see. *Your skin is dry. It's too dry in winter*. I open the tub and lift it beneath my nostrils. At least I can still smell. Pungent, unmistakable: Vaseline.

by Alexandra Hoffman

Hold by Eva Long

The Birds

My little sister always had the strangest belief about birds. It all started when we were younger and my mother began collecting these small bird statues, the kind you find in the craft store under painted wood with Bible verses in script font. My sister told me that they came alive at night and ate the concrete off the basement walls. She said they were digging. When asked where, she would simply say, "To the other side."

Of course, I never believed her. The concrete was always the same, uneven surface it had always been, it never seemed thinner. My father told me it was her overactive imagination and we left it at that.

My mother died the fall before the birds disappeared. It was a freak accident. A man being chased by the cops swerved in the oncoming lane and, well I don't need to explain the rest. My sister took it especially hard. She was a freshman at a university in Pittsburg and after the funeral, she didn't go back.

It was February, around Valentine's day and I was living at home, to make sure my sister and father were all right. They needed the extra income, besides. Then one morning all the birds, and there were a lot of them, they were just gone. I thought Dad might have packed them up, that it hurt to look at them, but he was just as confused as I was.

I was taking out the trash when I saw them. For some reason, I looked up at the roof and there they were. Hundreds of birds. Ceramic and plaster and clay and marble even. Some I don't even think my mother owned. But that wasn't the strangest part. They were pecking at the roof. It's strange I didn't hear the noise because it filled the air after I saw them. And some of them were breaking as they pecked at the roof. Their beaks shattered off, but they kept pecking until their heads broke off and then they threw what was left of themselves at the roof. And I couldn't look away. I just watched my mother's birds break through the roof. I don't know how long I stood there, it must have taken them an hour or so. My sister came out eventually and we stood there together.

"What the hell are they doing?" I finally voiced as the birds worked on expanding the hole in the roof.

"They are trying to get to the other side. They are trying to get to her." She sipped her coffee from a bird-shaped mug. After she finished she climbed the front porch and placed the mug on the lip of the roof. As she climbed down the mug walked to join the ceramic birds. "I think I'll go with them."

"Now why would you do that?" For the first time since I got the phone call from my father that night in October, I was scared.

"Because, I think I would shatter too, if it meant getting her back. I think I would rip the entire house apart to find her. Just for a second. Just for a goodbye."

"I think I would too, Leah."

My father came out and we watched as my mother's birds brought the house down. All that was left was bird bodies and wood and plaster.

And I cried. There in the front yard. I didn't even cry at her funeral, I couldn't. Not in front of Leah and my dad. But as the bird's body stilled, it felt like I was watching her. I felt like I was watching her.

by Natalie David

Lemon Drop Martini

Whenever the flu or head cold or sheer angst waylaid me, my dad—my real dad—let me stay home from school and watch *The Wizard of Oz*. Sometimes he'd call in sick too, and he'd persuade Mom to follow suit. We'd huddle together under a stained duvet, white-and-azure-splashed after my five-year-old room-painting jamboree. He'd point out the gorgeous liberties the set designers had taken with the flowers. Occasionally we'd press PLAY twice.

My friend Kate once bought me a '*making of*' volume. I read two chapters (she'd dropped $25.99) then committed it to the library's donation bin. It only undercut my happy ignorance of the exploding broom, unconscionable makeup injuries, and Toto's out-earning the actors.

If I could simply *exist* over the rainbow—

where trouble melts…

amid Technicolor brilliance / glorious florae / the overwhelming conviction that goodness would triumph—

without tests / passive-aggressive classmates / reliving Dad's last lily-scented, screeching-monitor moments a year ago.

Then, earlier this morning:

"Susan." Jonathan, perforating my mother's name.

"Mandy's—ill," my mother faltered, only then remembering to retrieve the plausible thermometer from her apron pocket.

"I see." Jonathan's Disney-hero jaw worked, clicking away billable minutes.

"Mandy—could—maybe you'd better, ah, go."

Jonathan had selected my mother over the fifty-odd glamorous divorcées he had successfully represented. Possibly because her responses to his overtures began with, "Oh, dear, I couldn't," and ended with, "You're probably right."

"…and avoid additional Cs in trigonometry," Jonathan added. "With daisy-doodles in your margins."

"Probably inevitable."

Thereafter: Jonathan's legal/almost clerical strictures on Diligence. And punctual reminders to my mother that her indulgence would only solidify my (a)pathetic trajectory.

Now, I'm loitering on the cracked pavement before Hoover High's drab façade, waiting for Jonathan's car to turn the corner…

…gone.

Finally.

I cut first period and purchased affordable carnations before slouching toward the cemetery.

by Linda McMullen

College. A two-hours-distant branch-campus of Midwestern State University sufficed. I went to class, sometimes—pajama-ed, often—and haunted the ribbon paths of the campus gardens. I called Mom weekly, reporting on none of this. She texted me pictures: Jonathan called her "a prime-of-life icon" after

— selecting a bleach-silver pigment for her hair.

— taking up Zumba.

— losing twenty pounds.

After I stumbled into a dozen seminars, the botany professor lovingly press-ganged me into his classes. A significant improvement on trigonometry. Horticulture, landscape design, ecology…*branching* out. Dr. Gentius recommended me for a Public Gardens internship three states away. I raised it during a visit home.

Jonathan folded his arms. "We're not wasting thousands on—"

"It's *paid*."

"—it's *far*—"

"I'm twenty-one."

"—even if they *did*…take you."

"They have," I said, extending my glowing phone face toward him.

Mom sputtered, "Honey, maybe—it's—I…"

"I'm going out drinking to celebrate," I said.

I brought Dad wildflowers first.

The bartender approached. "What can I offer you?"

Journeys beyond the rainbow?

Restrained glee couldn't melt away my troubles, as Miss Garland once sang…but…

"A lemon drop martini, please."

Visions of a Blind Fountain

Blindness, a trip with everyone and everything

feels touchy-feely, makes Beth blink less, and she

can tell when I lose the game. I hide my anger, say,

"The garden looks fresh. Vines wrap the fountain, eh,

and it looks like lovemaking after a long sentence."

Beth smiles away my cruelty. I lick cans, stones, all

that falls in my way back home. At night I have a vision—

Beth stalks me, and I cannot escape her diligence.

I am a snake, and Beth, a fountain. Only she gurgles,

without any wetness. I know dreams can show why I

return everyday to Beth, lose a battle of blind results.

I know Beth, and her hatred of winning a game where both

want to lose.

by Kushal Poddar

Sun Tides
by Megan Dobson

the drive before i left

the tracks by tyler untore themselves with the summer
buckled back up so i could exit like this

smoothly
softly
perhaps

this was how we're meant to be
rolled right on red
detour off smith

you tuck my name in your fingers
you hang your fist out the car

by Carmela Furio

From The Inside Looking Out

by Taj Stoddart

A Better Art

by T.W. Selvey

LAST ONE OUT OF TILLER, TURN OUT THE LIGHT

streetlamp, stutter me a promise through shard-

teeth: i will not abandon you to the dark

windows. i will not board you as a door

condemned. i will not only enter you as dead.

it's a different threshold we walk, townies between

worlds, newly-nomad from deep-rooted ghosts.

the diner is metal on all sides, becomes what

it reflects: all neon & flicker. there's a wound

in the booth corroding to dehisce. gut your stuff

ed animals & bleed them of all their stuff. some worlds begin

a cling-wrapped series of dust-blown figurines who left no space

to move & packed themselves for storage. some mother-

daughter relationships come with particular assembly

instructions & breakage results in a loss of respect. some childhoods pass

in & out of churches, starving for a pinch of flesh.

some gods live in the taste of homemade sour

dough or the mile of forest between you & the next

four-person home. sometimes you won't know

the god exists until the windows are open & you're hurtling

downhill & it hits you all at once. what are we made

of? tight fists. high beams. night fog. that bottled feeling

when the jeep free-falls to the bottom of the hill, windows down & we're screaming

IT DOESN'T HAVE TO BE LIKE THIS KILLER WHALES

like our lungs depend on being heard – maybe

there was a gas station back there.

maybe we missed it.

by Amy Jannotti

creator bios...

Murray Hines

Murray Hines is an aspiring writer, educator, and connoisseur of the fine life currently completing his studies at the University of Cape Town in South Africa. Through his work he hopes to make fun of everything and everyone and carry out his political project of finally getting Amy Adams that Oscar. In his free time he buys too many books, drinks too much wine, and thinks deep thoughts.

Madison Bartlett

Madison Bartlett is a student at the University of Iowa from Cedar Rapids, Iowa.

Kailey Mgrdichian

Kailey Mgrdichian is a junior majoring in English and creative writing and secondary education. She likes to write novels, cuddle with her sweetly demonic cat, and generally bite off more than she can chew.

Gavin McAllister

Gavin McAllister is a Chicago artist, born and raised in the South Loop. Still developing as artist, he has a wide range of styles and mediums. Currently, he is pursuing a mechanical engineering degree at the University of Iowa. He hopes to ultimately do design work in the automobile industry. He can be reached at gavin-mcallister@uiowa.edu.

Benjamin Saloga

Benjamin Saloga is a sophomore and an English and creative writing major from Sugar Grove, Illinois. He's also a member of the Army ROTC program here at the university.

Kayleigh Hordjik

Kayleigh Hordijk is a 20 year old who is currently studying law at the University of Cape Town. They would like to specialize in environmental law and are very passionate about the Earth. They are also passionate about the arts. They started painting when they were 16 when they took art as a subject in high school.

Hordjik cont.

They were first in their grade for art at the end of their final school year in 2018, and they submitted their work in the Sanlam Portrait competition in which they made the top 40 and had their work displayed in a gallery in 2019. This painting, 'How We Should Be Born', was one of their school projects when they were 17 with the topic being 'Juxtaposition'.

Leiz Chan

Leiz was born and raised in Des Moines, Iowa, coming to Iowa City to study English and creative writing. While writing continues to be her main passion, she balances it out with drawing and painting, as well as playing the sousaphone for the Hawkeye Marching Band. She hopes to write (and complete!) fiction novels with short pieces on the sidelines.

Eva Long

Eva Long is a junior studying art with an emphasis in graphic design. They really enjoy photography and creating collages. She thinks that the time or state that she's in helps her to make collages because the thoughts that she has makes her process how she'll make the collage.

Long cont.

Normally, creating something really helps them keep their mind off of what's actually going on inside their brain, as a healthy coping mechanism. They really appreciate and value creativity and they hope that everyone finds or will find an outlet as they have.

...in order of appearance.

creator bios...

Elsa Richardson-Bach

Elsa Richardson-Bach is from a small town in Massachusetts. She ventured out to the University of Iowa for the writing program and enjoys how much nicer the drivers are out here. Her most used phrase is, "How hard can it be?" which has led her to as much success as it has thrown her in the deep end. Luckily, she grew up on the coast and knows how to swim. She doesn't have a nemesis but thinks one would be neat. Applications are open.

Hannah Rose Showalter

Hannah Rose Showalter is from New Boston, Illinois, and currently lives in Iowa City, Iowa. She is in her fourth year of college and will graduate (someday) with the goal of being a public librarian. When she's not writing about sad things, she can be found writing silly children's stories for her friends in exchange for tacos, and singing show tunes off-key.

Joey Wolf

Joey is an art student at the University of Iowa with intentions of becoming an animator. He is actively creating art that exposes our society and forces others to confront our harsh reality.

Simthandile Lisakhanya Witbooi

Simthandile Lisakhanya Witbooi is a Cape Town based mixed media artist and poet. She predominantly does portraits using pencil color or acrylic paint. She then creates a variety of textures, images, collages and plays with other forms of materiality that are interwoven into the piece, resulting in a harmonious and aesthetic whole, layered in meaning.

Lisakhanya Witbooi cont.

She is currently doing a Bachelor of Arts at the University of Cape Town, which she balances alongside her budding art career. You can find her work on her website simthandilecreates.com.

Meg Mechelke

Meg Mechelke is a second year student at the University of Iowa studying theater arts and creative writing. She has previously been published in *New Moon*, *Quarantine*, and *Foolish* magazines.

Amanda Pendley

Amanda Pendley is a queer twenty one year old writer from Kansas City, who is currently studying creative writing and publishing at the University of Iowa. Her recent and forthcoming publications include *Homology Lit*, *Vagabond City Lit*, *Savant Garde Literary Magazine*, and *The Shore*. She often finds inspiration in Lorde songs, movement, and Harry Styles' suit collection.

Ciara Flashman

Ciara Flashman is a student at the University of Cape Town majoring in English. Her passions lie in people and the arts (which are one in the same) for she believes they are the connections to the world.

Nicole Adams

Nicole Adams is a second-year student at the University of Iowa, majoring in English and creative writing along with the publishing track. She began to explore writing creative non-fiction at the beginning of 2020 and fell in love with the genre.

Betsy Smith

Betsy Smith is a senior in journalism and psychology at the University of Missouri. The main medium she works in is photography, but she enjoys every aspect of the creative field including textiles, fine art, graphic design, writing, and more. There's nothing she hasn't tried at least once. She always enjoys pushing the box with her art, incorporating tons of unconventional elements, from bubble guns and googly eyes to unique lighting and ornate sets.

...in order of appearance.

creator bios...

Smith cont.

She is absolutely blessed to have so many amazing models and friends who are always up for her crazy schemes and who never turn away from the possibility of having something glued to their faces. The beating heart of her work is the people in the frame and she is so grateful for everyone who has made such incredible magic with her over the last few years.

Sydney Vogl

Originally from Los Angeles, Sydney (she/her) now lives and writes in San Francisco. In 2020, she was chosen as the poetry fellow for the Martha's Vineyard Institute for Creative Writing. Her work, nominated for Best of the Net 2020, has been published in *Entropy*, *The Racket*, and is forthcoming in *Hobart* and *I-70 Review*.

Vogl cont.

She currently serves as a poetry editor for *The San Franciscan Magazine* and works as an educator to Bay Area Youth.

Grace Culbertson

Grace Culbertson is a third-year journalism and English and creative writing major at the University of Iowa. When she's not stress-cooking, she enjoys drinking ginger peach tea, taking "depression naps," and yelling at anti-maskers. Even though she's horrible at copy editing her own work, Grace is currently an "-ality" section editor for the UI literary magazine, *Sanct*.

Kahill Perkins

Kahill Perkins is an author and multi media artist in the Lawrence Kansas area. She is a queer, biracial, radicalist with an obsession of all things lemon and femme. Author of a collection of poetry featured in her book, *Bite Back*, and an all around laugh. Watcher of period films, reader of dusty books, practitioner of old magic, just a girl.

Kyler Johnson

Bursting with energy and passion, Kyler Johnson has a goal to bridge the world together through the power of language. Studying English and creative writing, Portuguese, Chinese, and German, he seeks opportunities that allow him to practice his languages and/or tell stories.

Johnson cont.

As a former editor of *Ink Lit Mag* and current member of both the bilingual journal *Das Blatt* and the *Translate Iowa Project*, he enjoys taking part in the campus literary scene. Spending a full year prior to college in Charleroi, Belgium, he hopes to continue traversing internationally to places like Brazil and China to keep exploring new cultures first-hand.

Megan Dobson

Megan Dobson is currently enrolled as a graphic design student at the University of Northern Iowa. Her work is inspired by beauty in the everyday and circumstances that evoke emotion. Her work has appeared in shows such as the Marion Arts Festival and the 29th League for Innovation of the Arts.

Dobson cont.

She currently works in her in-home studio for her small business while in school. She primarily works with photography, typography, and mixed media.

Luna Phalen

Luna Phalen is a junior at West Liberty University where they are an editor for the university's literary magazine *Ampersand*. When they aren't stressing over classes and writing poems as a way to procrastinate, they can be found working in their college's library. They hope to eventually pursue a Master's Degree in Library Science and become a university librarian.

...in order of appearance.

creator bios...

Alexandra Hoffman

Alexandra is a South African writer, currently completing her MA in English literature and modernity at the University of Cape Town. Her present research focuses on contemporary romance and how romantic narratives shape and reshape ideas of love and desire. Alexandra is passionate about literature, dance, film, and the arts more broadly.

Hoffman cont.

Alexandra believes that reading is a powerful tool for understanding and empathy. For her, literature's beauty lies in its ability to paint a nuanced picture of the world. Alexandra currently lives in Johannesburg, where she spends most of her time drinking tea and avoiding her dissertation.

Natalie David

Natalie David is a second-year art major from North Carolina, focusing on graphic design. She hopes to combine her love of art and literature by working in design at a publishing house. When she isn't creating, she is buying as many plants as her apartment can hold.

Linda McMullen

Linda McMullen is a wife, mother, diplomat, and homesick Wisconsinite. Her short stories and the occasional poem have appeared in over seventy literary magazines.

Kushal Poddar

An author and a father, Kushal Poddar, edited a magazine - *Words Surfacing*, authored seven volumes including, *The Circus Came To My Island*, *A Place For Your Ghost Animals*, *Eternity Restoration Project- Selected and New Poems*, and, *Herding My Thoughts To The Slaughterhouse-A Prequel*.

Poddar cont.

His works have been translated in ten languages. Find and follow him at amazon.com/author/kushalpoddar_thepoet
Author Facebook- https://www.facebook.com/KushalTheWriter/
Twitter- https://twitter.com/Kushalpoe

Carmela Furio

Carmela Furio is a sophomore at the University of Iowa studying publishing and Italian. She enjoys campus birds and long rants on the beach. Recently she changed her name spelling; if you want to know why she suggests you seek her out.

Taj Stoffart

Taj Stoffart is a photographer and a poet based out of Houston, Texas. They create work that combines the art forms of photography and poetry to show their perspective of the world through their eyes and words.

T.W. Selvey

Recently, T.W. Selvey's work has appeared in *The Shore*, *The Wild Literary Journal*, *The Pi Review*, *Feral*, and *petrichor*. T.W. tweets sporadically @docu_dement, and is the proud curator of a haphazardly curated blog, www.documentdement.com.

Amy Jannotti

Amy Jannotti (she/her) is a pile of dust in a trenchcoat living and writing in Philadelphia, where she received her Bachelor of Fine Arts in Creative Writing from the University of the Arts. Her work has been featured in *Non.Plus Lit*, *Burning House Press*, *Charge Magazine*, and elsewhere. She tweets @cursetheground

...in order of appearance.

meet the team!

Mikey Waller
Co-EIC

She was born in Cincinnati, Ohio and grew up in Fort Dodge, Iowa. She is currently a second year English and creative writing major on the publishing track with a minor in art. Last year, she was the Art Editor for *Ink Lit Mag* in both the fall and spring semesters. She was also a finalist for the *Iowa Chapbook Prize*. This year, she is an Art Editor for *earthwords: the undergraduate literary review*. Her writing and artwork can be found in *Ink Lit Mag* (Issues 17 & 18), *Foolish 8.5*, *Mirror Mag*, and the Blank Honors Center.

Catalina Irigoyen
Co-EIC

She is originally from Argentina, but moved to Iowa City from Quito, Ecuador. She is a third year student on the publishing track at the English and creative writing program at the University of Iowa, and is minoring in anthropology. She has prior experience working for Ecuadorian newspaper *El Comercio*, the Ecuadorian government's communications branch, freelance writing and creative writing consulting for Páramo Snacks, as well as having been the EIC for her high school's newspaper.

Kaitlin Channell
Managing Editor

She's a junior at the University of Iowa as an English and creative writing major on the publishing track with a minor in French. In December of 2019, she was published by the Barnes and Noble Press in *Growing Pains: an anthology*. Through 2017-2018, she was a Features Editor of *The Viking View newspaper*. Her article "Misconceptions of Feminism," won first place in Social Commentary by the *Long Island Journal Press*.

Emily Wiegand
Managing + Nonfiction Editor

She was born and raised in Spencer, Iowa and moved to Iowa City in 2017 to start her freshman year at the University of Iowa. She is now a senior majoring in English on the publishing track and minoring in psychology. As a freshman, she worked as a Staff Writer for *College Magazine*. She uses the knowledge she gained as a writer for the magazine to better understand how to edit pieces for *Zenith*. After graduating in May, she hopes to continue on the path to becoming an editor in the publishing industry.

meet the team!

Hayden Williams
Art & Design Editor

She is a second year student at the University of Iowa studying journalism and English on the publishing track with an art minor. She hopes to one day go into publishing, specifically with a focus on design. Her day to day at *Zenith* includes creating social media graphics, designing elements for the magazine, and overseeing the wonderful art team.

Charlotte Komrosky-Licata
Co-Editor, Illustration & Design

Raised in St. Louis, Missouri, she is now an Iowa resident and student in her third year pursuing a degree in business analytics and information systems and a creative writing certificate. In 2019, Charlotte was an executive member and Art Director for the student-run organization, M.E.S. (Media Entertainment & Lifestyle), as well as operating as a freelance artist. In addition to being on *Zenith*'s editorial team, she is also currently working as a colorist for an independent comic book.

Madi Meek
Marketing & Publicity Director

She is from Watertown, South Dakota and is currently pursuing an English and creative writing along with a publishing degree at the University of Iowa. She hopes to one day be a traditionally published author and have a fanbase of her own. Madi is involved with the Black and Gold Figure Skating Club along with Alpha Delta Pi Sorority. She can't wait to see where these organizations and *Zenith* takes her.

Eden Smith
Assistant Editor

She is a fourth-year student at the University of Iowa, where she studies journalism and creative writing. She has written for a number of campus publications including *Fools Magazine* and *Verve Magazine*. Eden is also currently a member of the Bijou Film Board's Open Screen committee.

meet the team!

Elyse Apple
Assistant Editor

She was born in Illinois and now resides in Iowa City, where she's attending her senior year at the University of Iowa. She is majoring in English and creative writing with a publishing minor. She particularly enjoys fiction writing and hopes to write her own novels someday probably while working for a book publishing company. She hopes to be able to enter the study abroad program and expand her range of knowledge overseas.

Maya Penning
Assistant Editor

She's a third-year student studying English and creative writing on the publishing track, with a minor in communication studies. In her time at the University of Iowa, she's been involved in *Ink Lit Mag* and various student organizations. She's also involved with the Iowa Youth Writing Project as an Events and Communications intern.

Evalyn Harper
Fiction Editor

Born and raised in Stillwater, Oklahoma, she moved to Iowa City to study English and creative writing on the publishing track. She has contributed work to *Ink Lit Mag* and the *Barnes & Noble Teen Blog*. Her ultimate goal is to become a full time kidlit author, but for now you can find her recommending books she loves on her YouTube channel, heretherebemagic.

Sarah Moss
Fiction Editor

They are a senior at University of Iowa majoring in English and creative writing. They are a long time Iowa resident and avid book reader and video game player. They enjoy writing short stories of both fiction and nonfiction and essays on popular culture.

meet the team!

Della Gritsch
Nonfiction Editor

She is a fourth-year student at the University of Iowa majoring in English and creative writing on the publishing track and education. She is from the small town of Iowa Falls, Iowa. Last year, she was the Lifestyle Editor and a writer at *Verve Magazine* and has written several fiction and non-fiction short stores, and some poetry.

Jillian Zeron
Poetry Editor

Originally from Los Angeles, California, she moved to Iowa City to attend the University of Iowa. She is in her third year double majoring in English and creative writing, and business. She hopes to step into the literary world through her time in Iowa.

Courtney Stearns
Poetry Editor

She's a third-year student studying English and creative writing on the publishing track. Her dream is to end up in Seattle or New York City working as an editing/publishing assistant and then work her way up the publishing ladder.

Jess Kibler
Zenith Mentor

She teaches literature, creative writing, and publishing, and is a third-year MFA candidate in the Nonfiction Writing Program at the University of Iowa. Before moving to Iowa, she copy edited and proofread for *Tin House*, *Bitch*, and *Longreads*, and worked as a bookseller at *Powell's Books* in Portland, Oregon. She received her BA in English literature with a minor in creative writing from Oregon State University, and she's currently at work on a book-length essay about coming of age in university evangelicalism.

your zenith horoscope.

aries

Aries, drive carefully! You're not the only person in the world, and your actions can have long-lasting consequences. A family secret may be revealed to you soon. Be on the lookout for new faces! Your lucky item is a memento from a loved one.

taurus

Taurus, nothing ever stays the same forever. You cannot stop the sands of time and will hurt yourself if you try. Be sure to stay open to new perspectives and you might just become more mature. Change will come where you like it or not, and sometimes, you just need to suck it up and grow up. Your lucky item is a red hunting hat.

gemini

Gemini, don't let your feelings cause you to make rash decisions. Your way with words isn't always a good thing and can get you into a lot of trouble. If someone calls you out, think about why they're telling you. It's often because they're the ones who care about you the most. Your lucky item is a childhood photo of you and your best friend.

cancer

Cancer, you may be feeling like your life is falling apart right now, but know that family doesn't have to be defined by who you're genetically related to. Make sure not to confuse being needed for being loved. Your real family is the people who care about you. Your lucky item is Thanksgiving leftovers.

leo

Leo, be open to new perspectives and experiences! You've been feeling trapped recently and are desperate for a way out. Sometimes all you need is a weekend away from the monotony of everyday life to truly find yourself. But remember to be safe! Your lucky item is a crumpled napkin with an illegible phone number.

virgo

Virgo, make sure not to lose yourself in worry! A new change is headed your way and you need to be prepared for it. Make sure not to lose sight of your goals, but don't be so caught up that you forget to enjoy the here and now. You're going to miss this when it's gone. Your lucky item is a graduation robe.

your zenith horoscope.

libra

Libra, you may be feeling very undecided about a relationship in your life right now. This relationship might have a history of see-sawing back and forth, and you're getting sick of it. Instead of acting rashly, give the situation time to cool down. Don't feel pressured to have an answer right here and now. Your lucky item is an old love note.

scorpio

Scorpio, you're starting to feel like everyone else is growing up without and it's making you feel childish. Your childhood maturity isolated you from your peers and suddenly they've left you behind. But make sure not to do things that you're uncomfortable with just because you think it'll make you an adult. Take things at your own pace and you'll find that you feel more sure of yourself. Your lucky item is a sweatshirt you've had since middle school.

sagittarius

Sagittarius, you like spontaneity, but sometimes impulsive decisions will leave you stranded in the middle of nowhere without a backup plan. Rely on your friends! Let others take the wheel sometimes. Sometimes it's not about the destination, but the journey itself. Your lucky item is a beat-up old Subaru Outback.

capricorn

Capricorn, there are new opportunities coming your way and you feel on top of the world. But being on top of the world means that you have a long drop if you fall, and that's making you nervous. New opportunities automatically mean new mistakes, so don't get too caught up if you're not succeeding as much as you think you should be. You'll get the hang of this eventually. Your lucky item is a pair of shoes that you haven't broken in yet.

aquarius

Aquarius, you're highly receptive to the emotions and experiences of other people, and hold a deeper understanding of who they are. People are flocking to you because you understand them, but do they understand you? Don't lose yourself in your plight to make others feel understood. You are your own person and shouldn't always cater to other peoples' needs. Your lucky item is a diary.

pisces

Pisces, you may find yourself experiencing emotions you've never felt before. A special someone has entered your life and is now consuming your thoughts. But be sure not to let your daydreams influence your decisions in real life. No one deserves to be held up against an unrealistic ideal, and you'll end up with a broken heart. Your lucky item is a pair of movie tickets.

fin.

www.ingramcontent.com/pod-product-compliance
Lightning Source LLC
Chambersburg PA
CBHW041924180526
45172CB00014B/1380